THROUGH CATI EYES

Andrews and McMeel
A Universal Press Syndicate Company
Kansas City • New York

First published in 1988 by Sidgwick & Jackson Limited 1 Tavistock Chambers, Bloomsbury Way London, WCIA 2SG

Through a Cat's Eyes copyright © 1988, 1989 Grub Street, London; illustrations copyright © 1988, 1989 by Toula Antonakos. All rights reserved. Printed in the United Kingdom. No part of this book may be used or reproduced in any manner whatsoever without written permission except in the case of reprints in the context of reviews. For information write Andrews and McMeel, a Universal Press Syndicate Company, 4900 Main Street, Kansas City, Missouri 64112.

ISBN: 0-8362-7979-4

Library of Congress Catalog Card Number: 89-84816

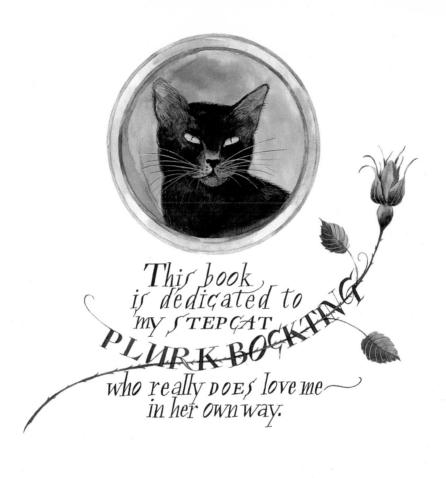

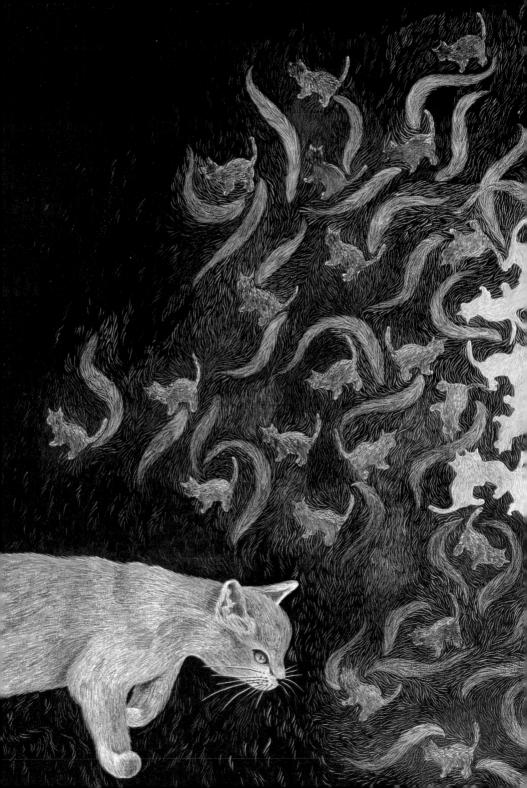

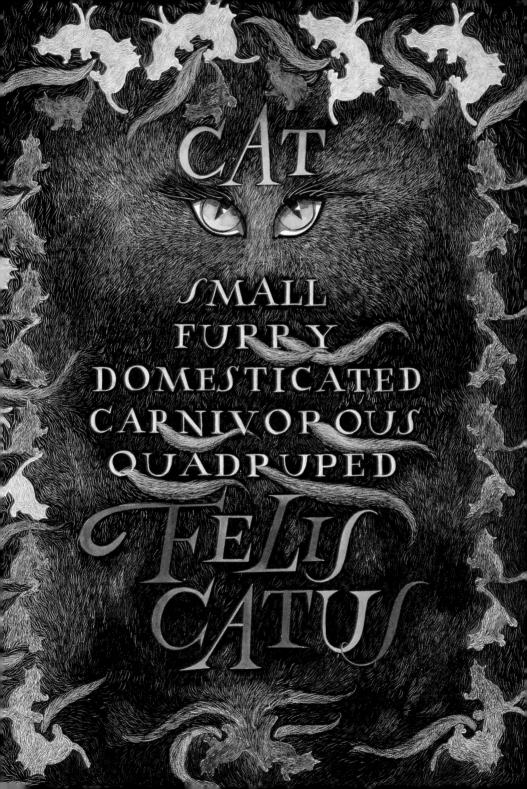

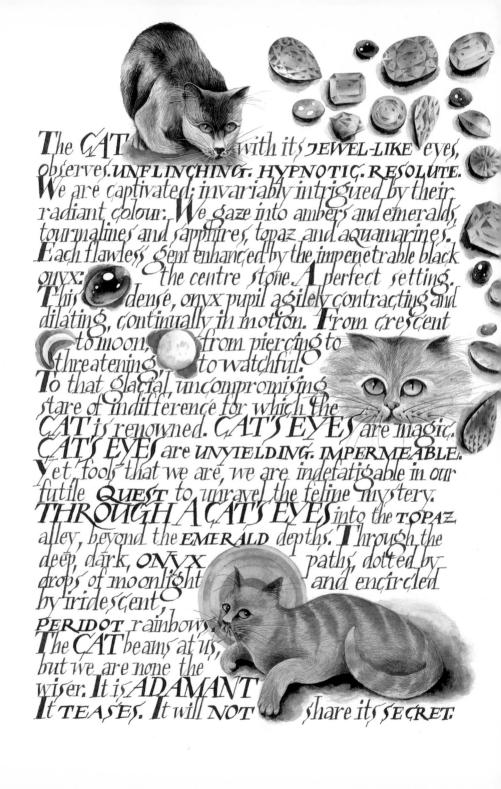

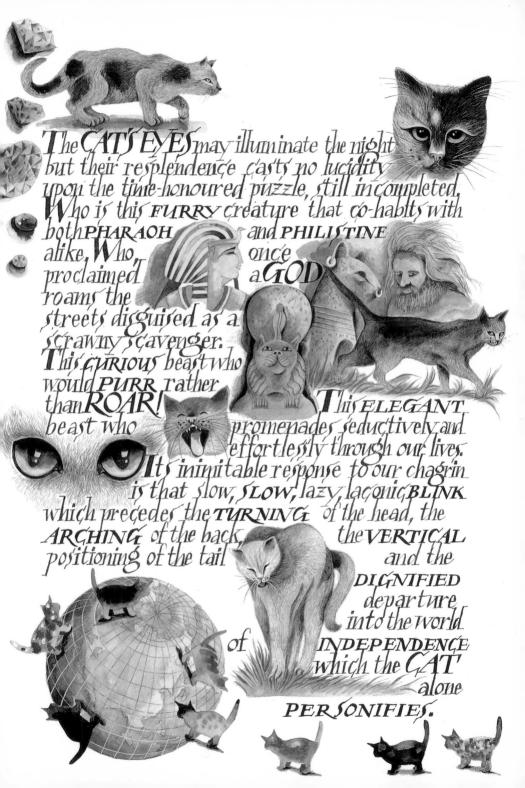

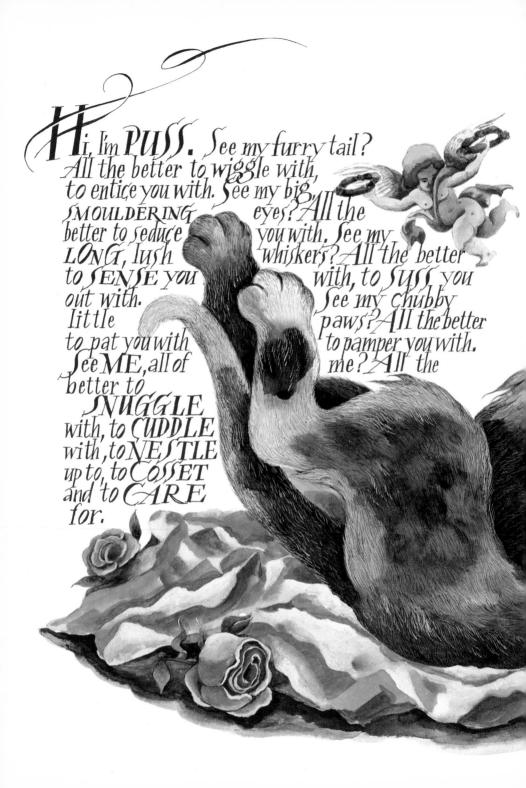

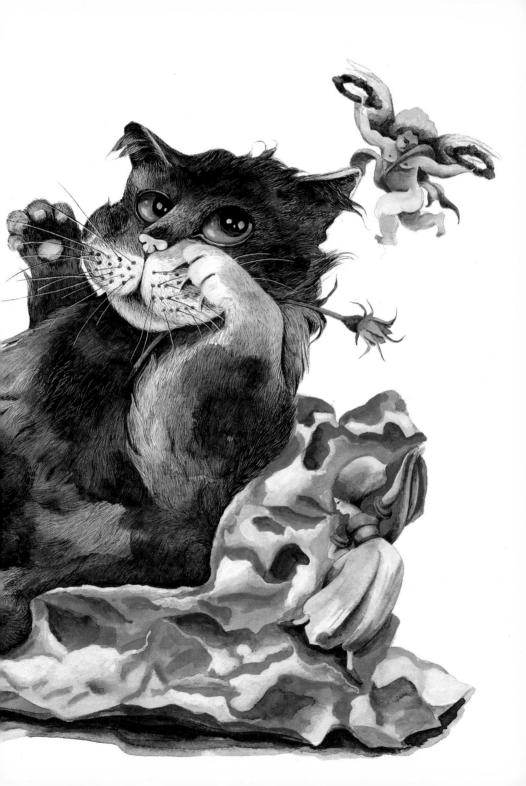

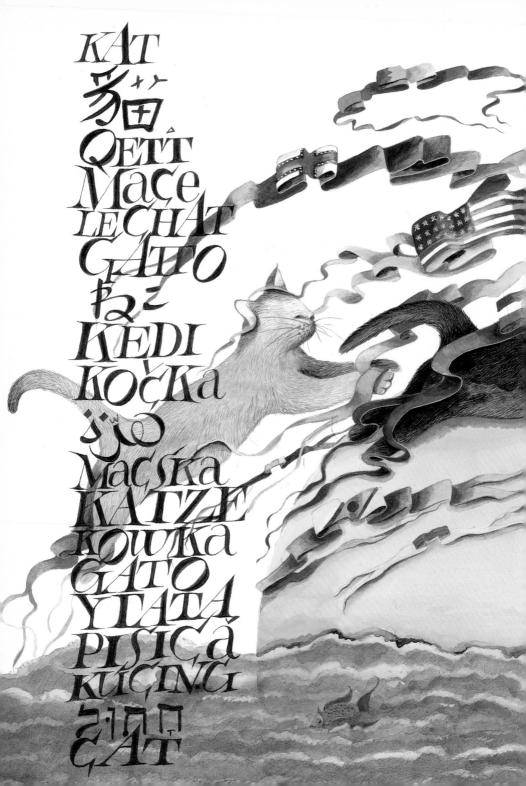

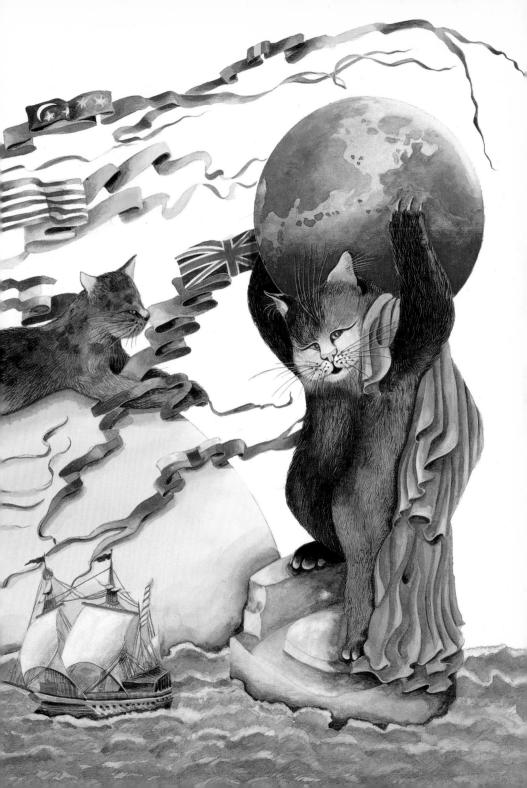

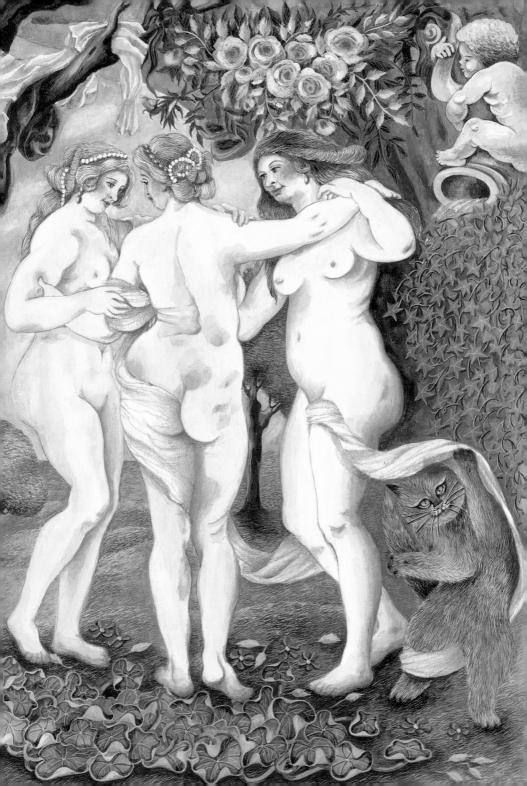

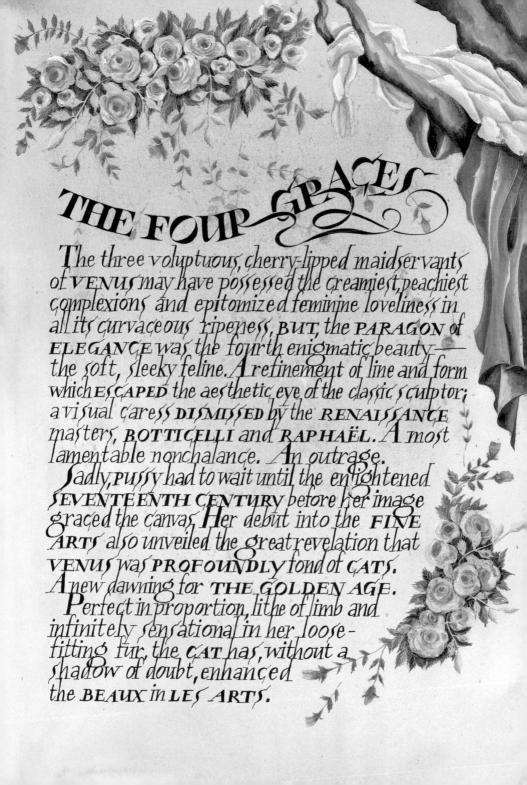

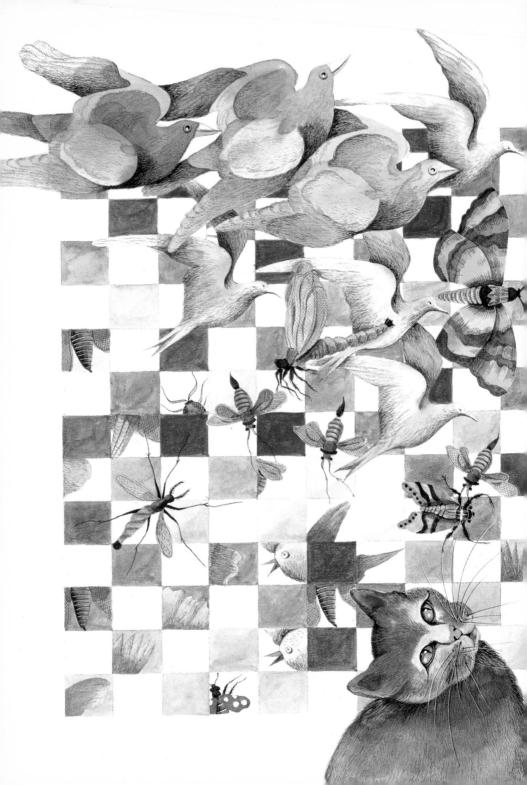

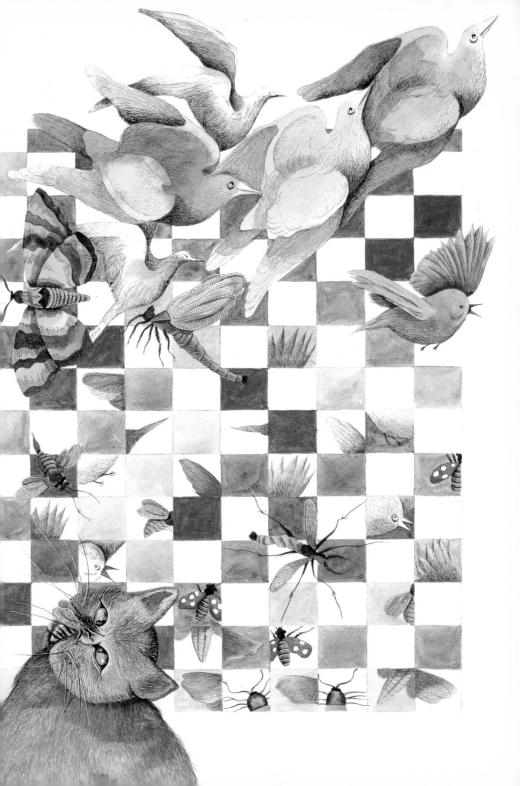

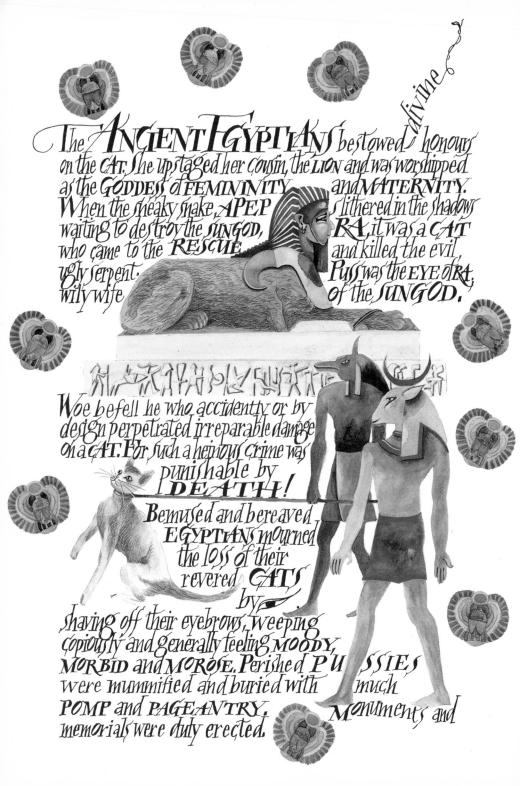

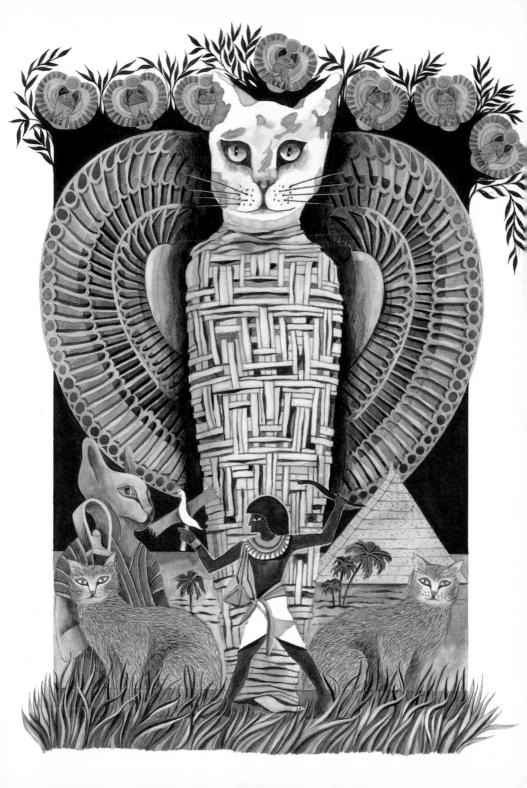

In elegant panatella, a box of creamy Belgian bon bon, and a bunch of red, red loses by the bedgide of an aging vepetre an civema. Here in the celebrity suite on the 52nd floor of the hotel Wisteria, poised in supine splendour; LA BELLE BLANCHE andher indolent dar mess. Weaned on Caviare champas VOL-AU-VENT and fish sticks are prevocably accustomed to luxury and excess KIND. Jo insufferably smu much time to prolonged and lingering abbutions, meticulous grooming and the general BEAUTIFICATION of the person the EYE of the to CARED BEHOLDER

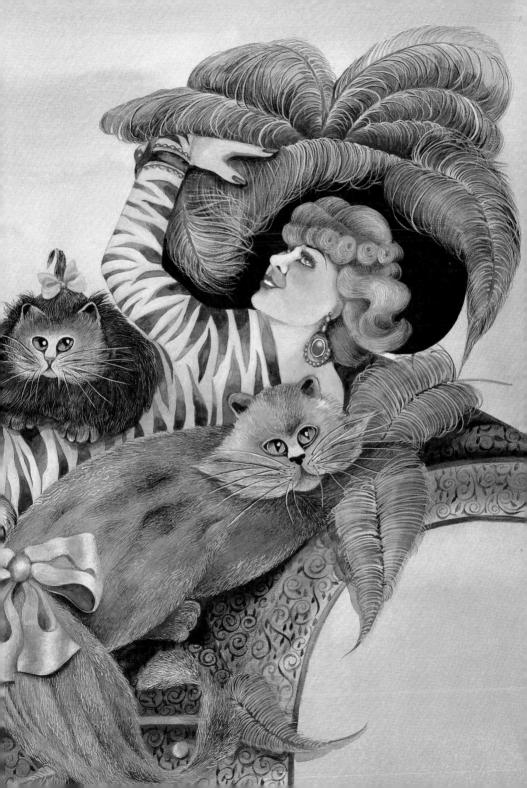

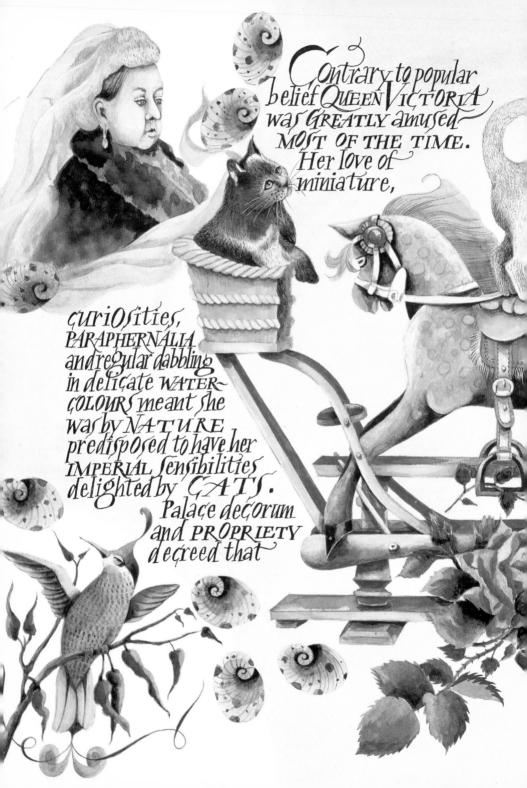

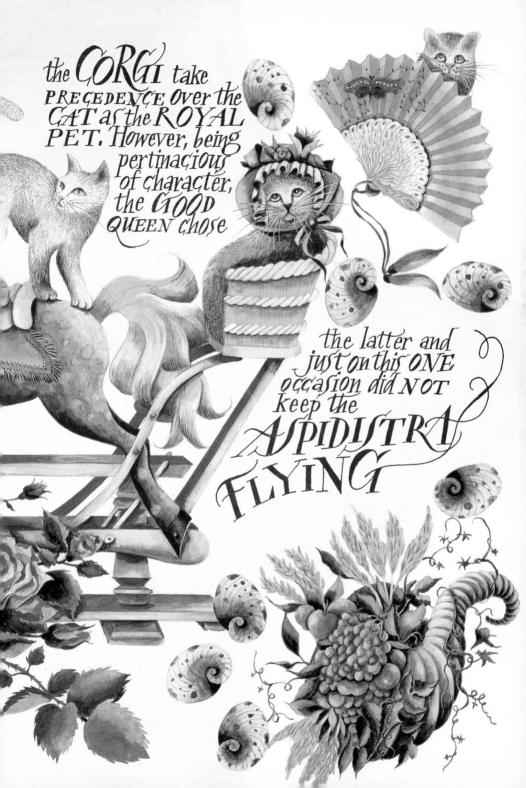

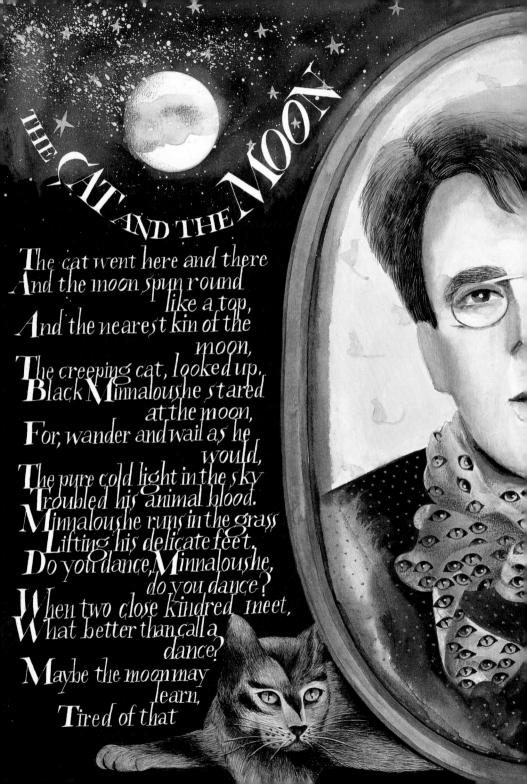

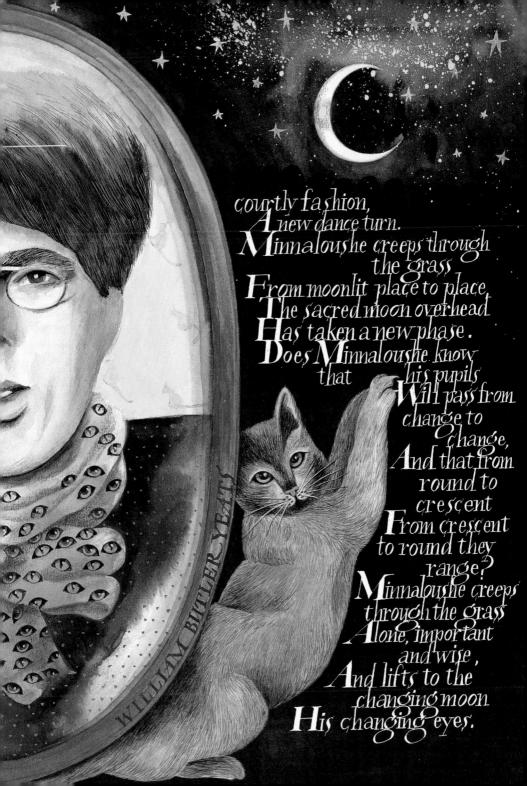

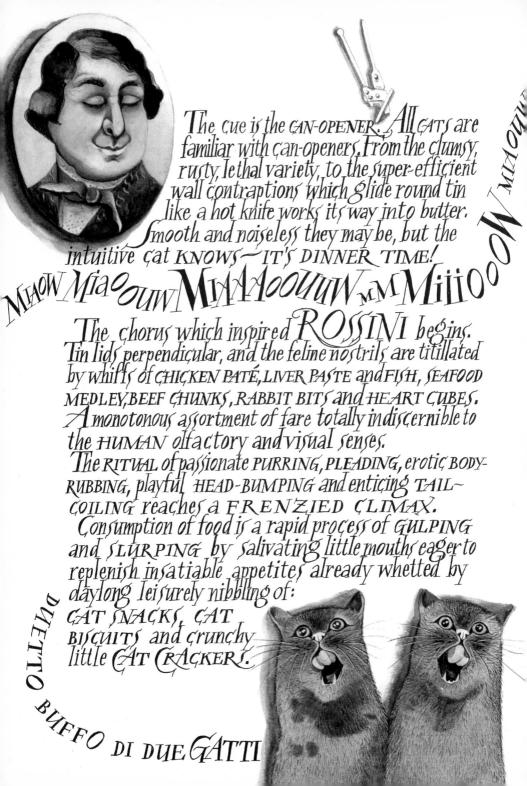

MIAOUW MM MM MM...

Take an Ordinary blanket of an Ordinary colour and an Ordinary texture and it is highly likely that Puss will leave it unsoiled, Ted and untouched. Take your most treasured Quilt of KALEIDOSCOPE.

colours created by skilful hands adept in century old traditions and watch its smooth satin fabric fray with car cally the Nics, torpid shumbers, and feline frivolities of a heartbreakingly destructive nature

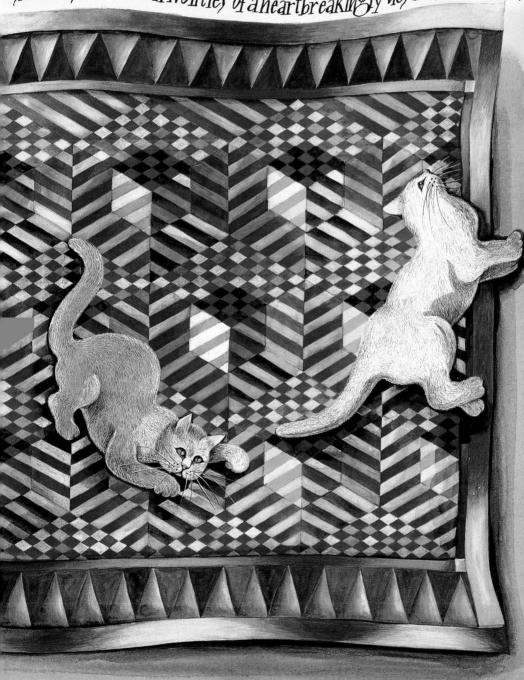

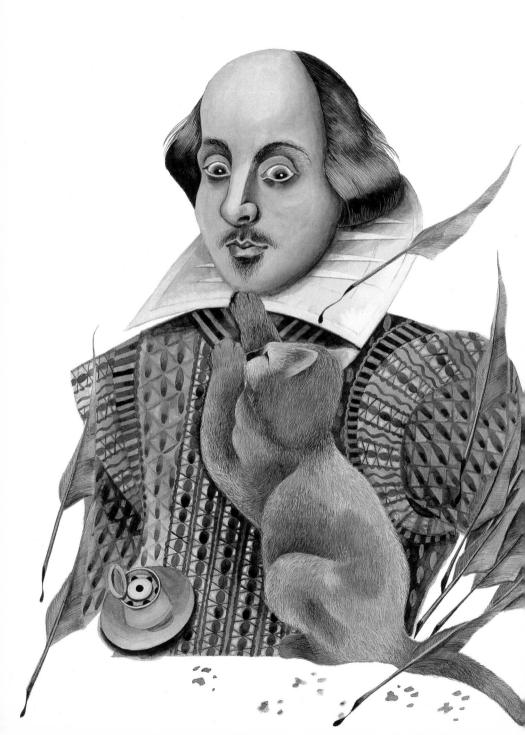

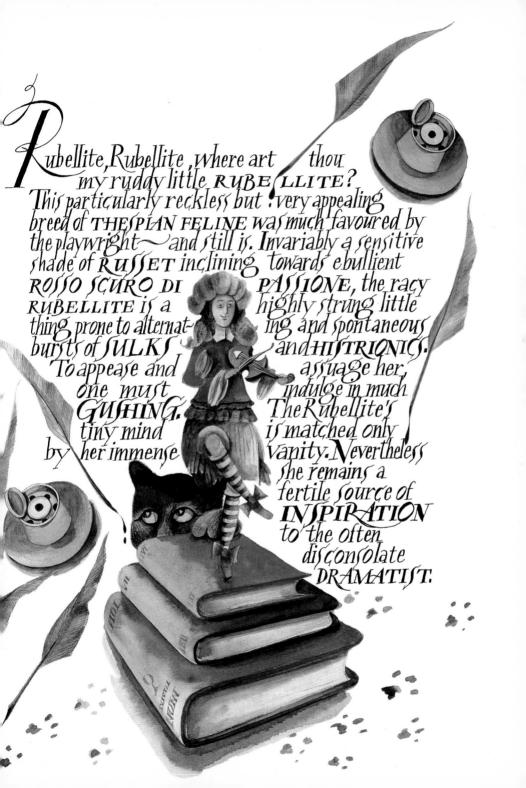

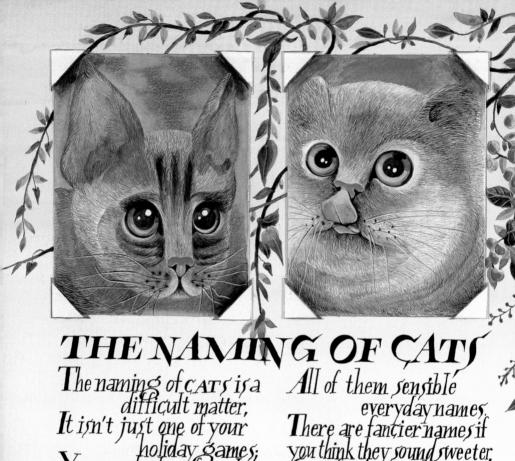

I he naming of CATS is a difficult matter, It isn't just one of your holiday games; You may think at first I'm as mad as a hatter When I tell you, a CAT must have THREE DIFFERENT NAMES.

First of all, there's the name that the family use daily, Such as PETER, AUGUSTUS, ALONZO OF JAMES, Such as VICTOR OF JONATHAN, GEORGE OF BILL BAILEY—

There are fancier names if you think they sound sweeter, some for the gentlemen, some for the dames:

Such as PLATO, ADMETUS, ELECTRA, DEMETER—But all of them sensible everyday names.

But I tell you, a carneeds a name that's particular, and more dignified, Else how can he keep up his tail perpendicular,

... by T.S. Eliot

Or spread out his whiskers, or cherish his pride? Of names of this kind, I can give you a quorum. Juch as MUNKUSTRAP, QUAXO, or CORICOPAT, Such as BOMBALURINA, or else JELLYLORUM—Names that never belong to more than one CAT. But above and beyond there's still one name left over And that is the name that you never will guess; The name that no human research can discover—

But THE CAT HIMSELF
KNOWS, and never will
confess.
When you notice a CAT
in profound meditation,
The reason, I tell you, is
always the same:
His mind is engaged in a
rapt contemplation
Of the thought, of the
thought,
of the thought of his name:
His ineffable effable
Effanine ffable
Deep and inscrutable
singular NAME.

Intique, Contemporary, designer, makeshift
any type of furniture will do. The CAT's criterion in
making his choice of, CHAIR, for instance—for they do
settle on top of wardrobes and tables; under beds, inside kitchen cuppoards and chests of drawer—is whether or not it is the one which has long been established as, YOUR the battle of wills beQins and NEVER ends BRUTE FORCE is khown to be adopted as a means of regaining TERRITORIAL GROUND Cats also have a remarkah short memory for any past DIJGIPLINARŸ a*ctio*n,like: NO FRUITSDE MER DELIJNACKS FOR 1 SOLID WEEK. CATS have A concept of AUTHORITY: are ignorant of the laws pertaining to the RIGHT of OWNERSHIP; INSENSITIVE TO VERBAL ABUSE and INFURIATINGLY Indifferent toward your: O PLACE TO SIT. Cats are by nature inconsiderate. Vhat to do? IVE UP.

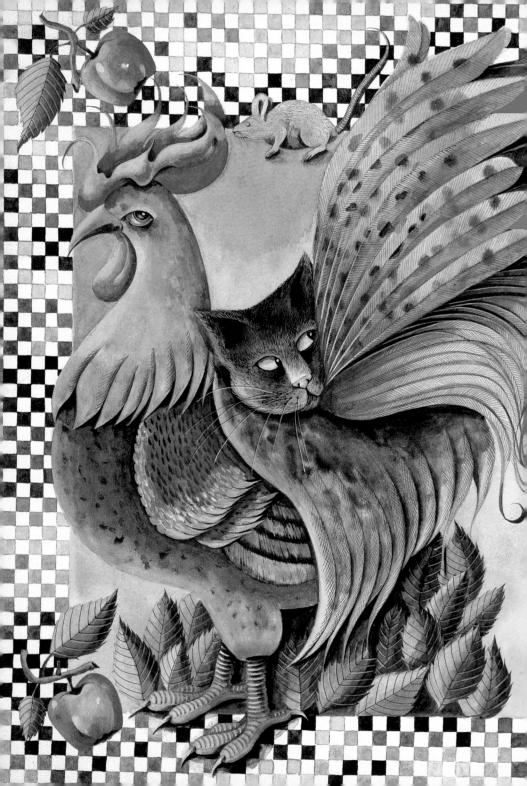

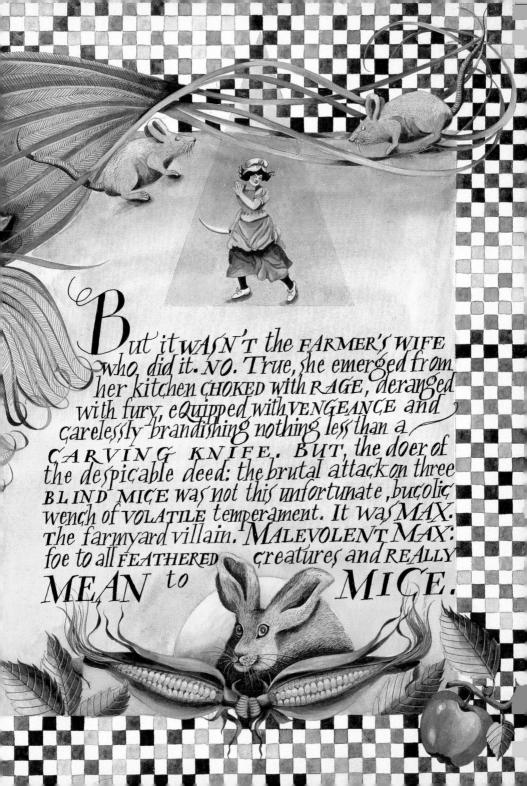

ne normally L**oqua***Cio***W** parakeet took on an uncharacterytically ACITURN demeanour caujing ing Suspicion that it was with CRUCIAL information. AA, the mOst eleQant of CATS, Sappeared, suddenly.Her untortunate condition as a result ot a SHORT but HIGHLY-CHARGED intatuation with C the WOMANIZER , transformed her from a, female of (LEEK, PROUD bearing to a bloated, shapeless bundle s WATER RETENTION and a rise in BLOOD PRESSURE. deligate condition and mysteriou abouts rose to a DISTURBING level A SEARCH PARTY WAS SUMMO tlower-beds were checkéd. boxes inspected. The wine cellar scanned with a SCRUTINIZING eye. The toolshed and broom cupboard investigated NEIGHBOURHOOD Questioned and OWNER NEXT dOOR CROSS Every nook and granny was péered no cushion was left unturned Al to ZIL CH. Not a TRACE of JA

lovable tace. I unanimous decision was taken to adopt a more clivical attitude and attribute it all to PRENPERIPATETIĆ QUIRĶI mitigating the severity of the situation and the impending gloom about to descend. Be side, hOw far can a CAT GO on SWOLLEN feet? The household retired for the nig Sometime later, the urgent need of an extension gord demanded a trip to the attic. An out bounds area due to indescribable mess, chaos, accumulation of junk and space of the Acureix CLAUSTROPHOBIC kind. A situation presenting no CLAUSTROPHOBIC kind. majór stumbling block for SASHA who was found trying to feed, comfort, wash and generally organise aridiculous number of PROGENY. She was brought downstairs-box and all where she gould REFLECT on the AL nature of LOVE, the DIRE DEBILITAT

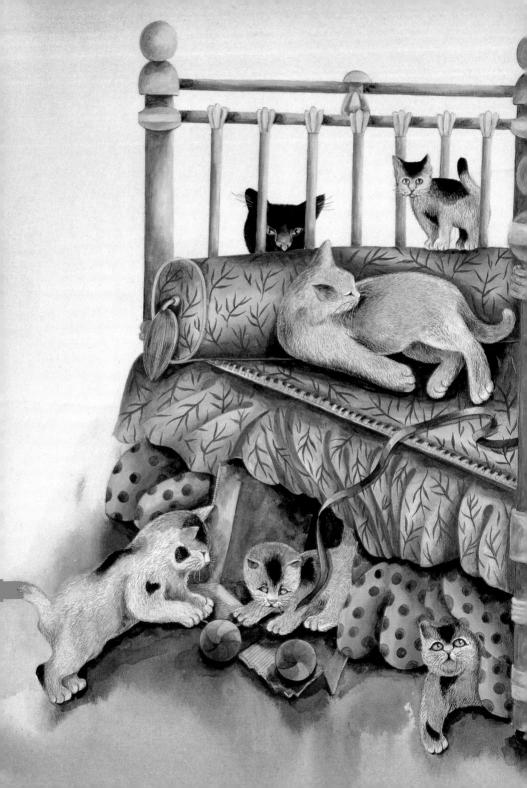

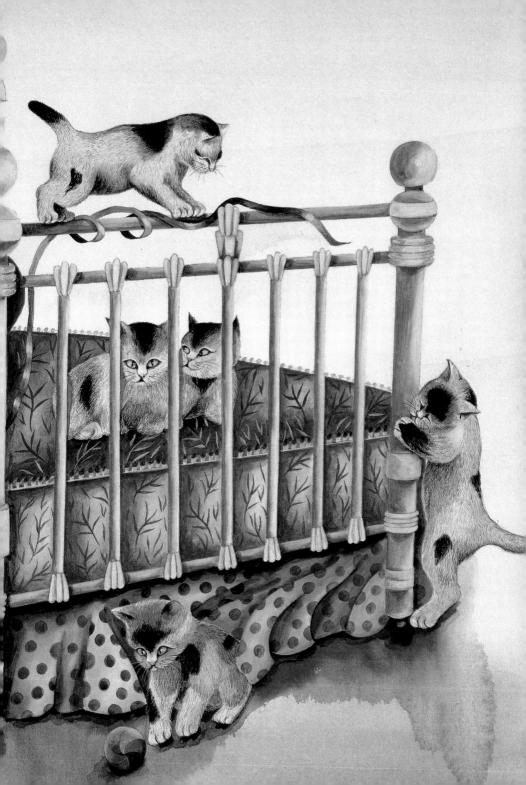

THE SUBTLE DELTA

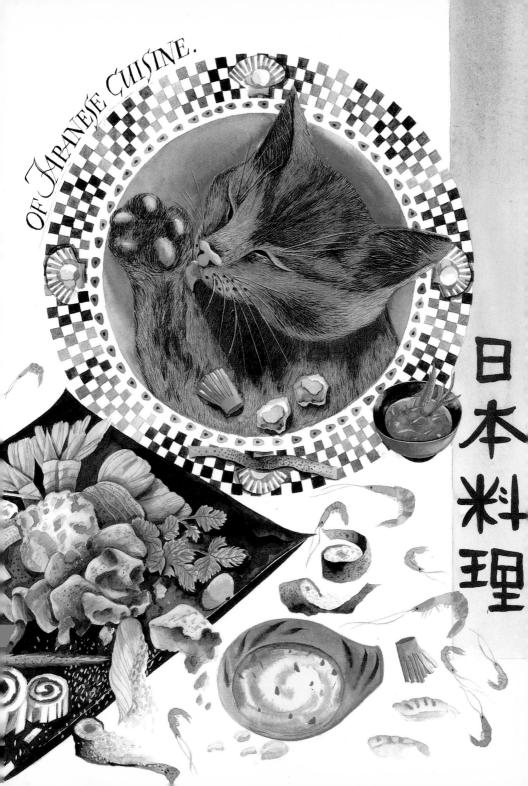

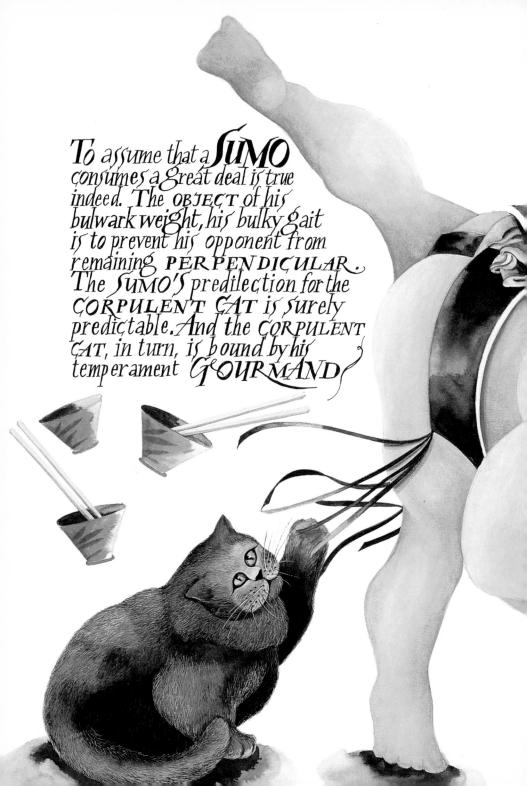

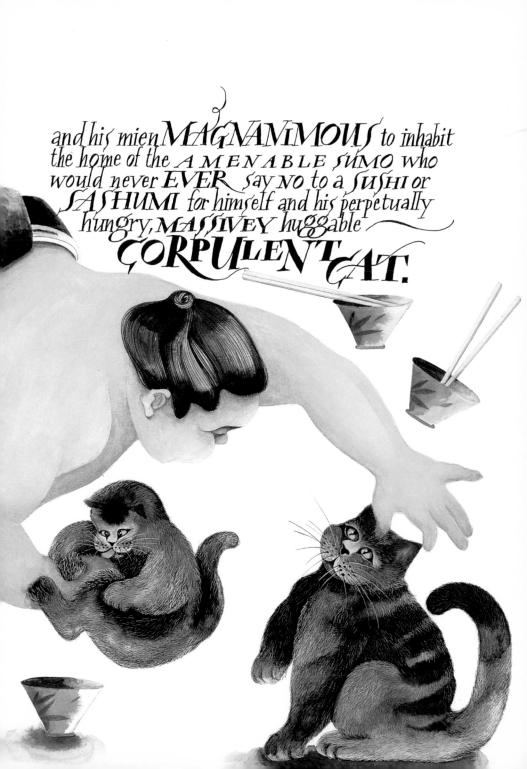

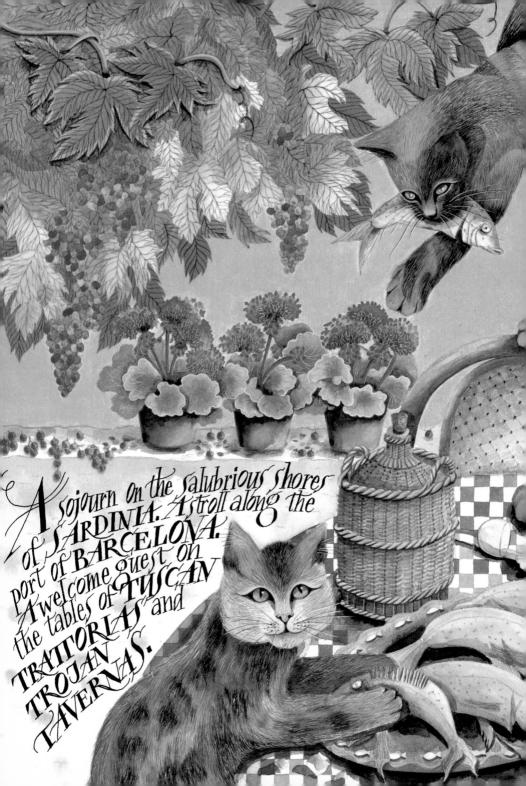

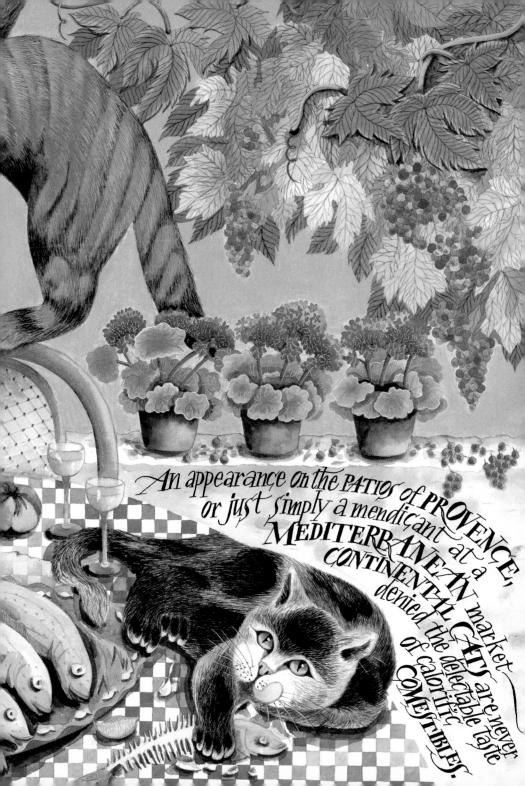

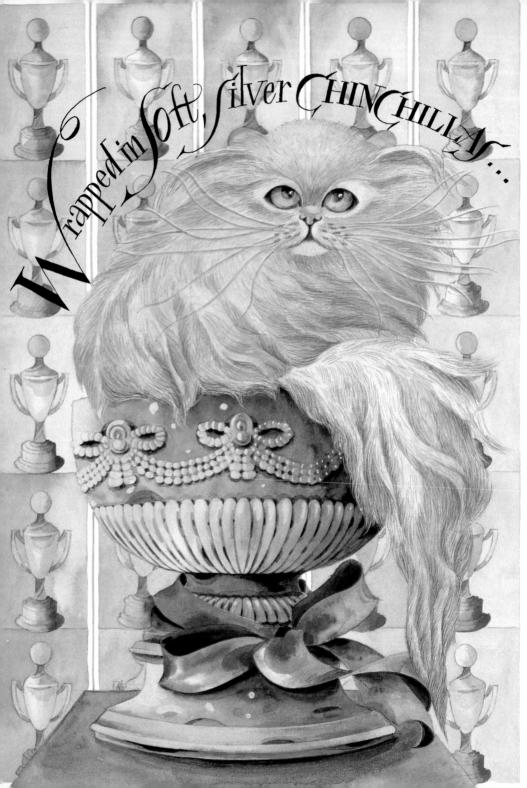

Wathed in priceless coats of the finest, and amending RIBBONS, ROSE LLES, SASHES and unending Unashamed with HAVIE With Unashamedly adorned the PRIZE are Pampered

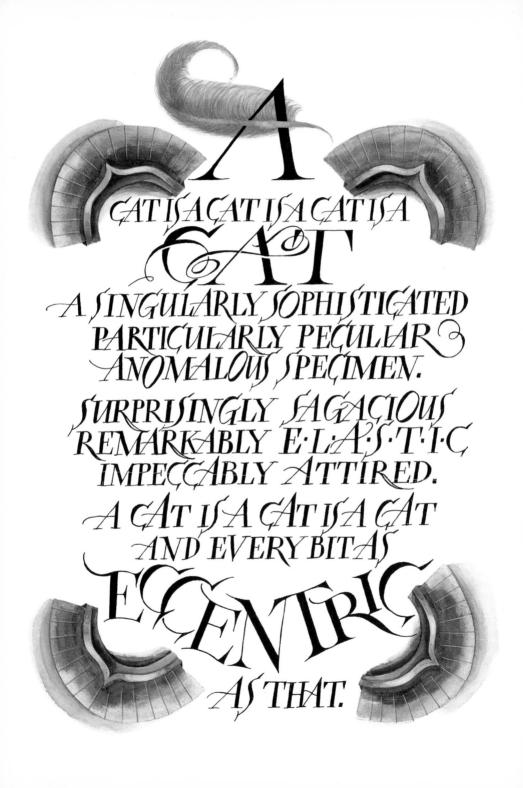

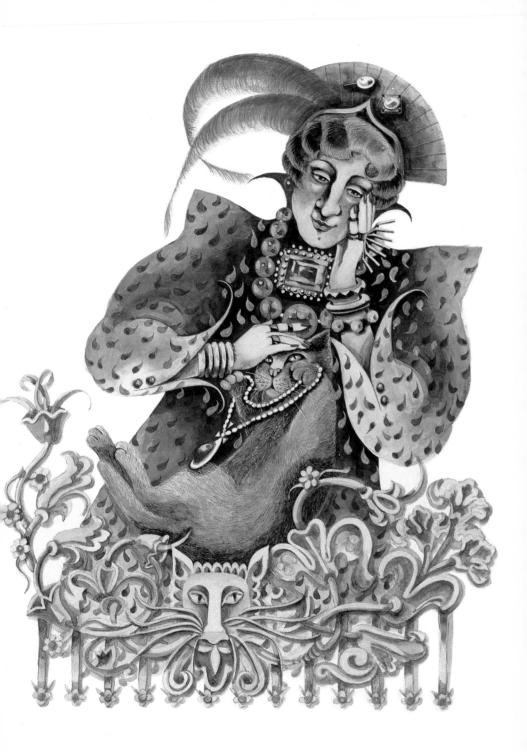

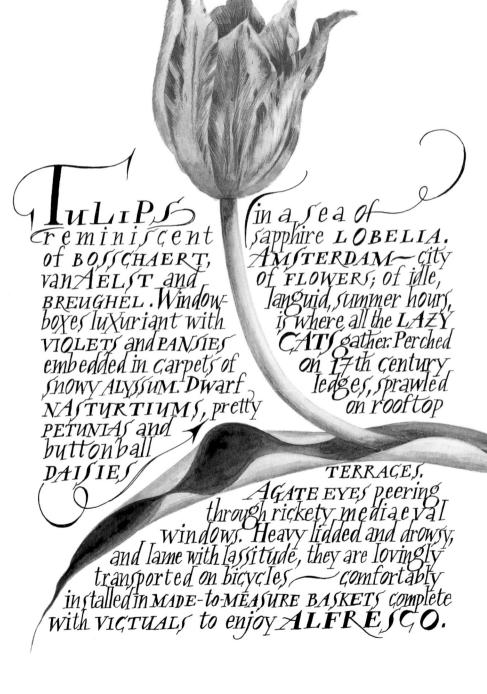

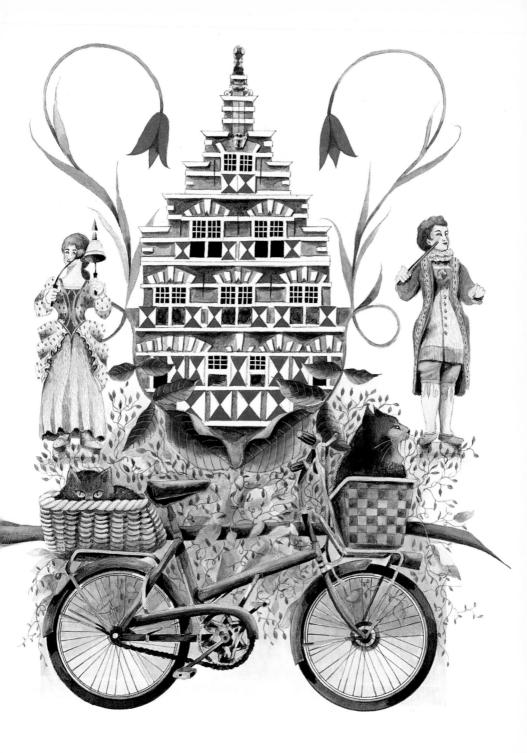

with slithery slim Similar Sind Mark The Mark The

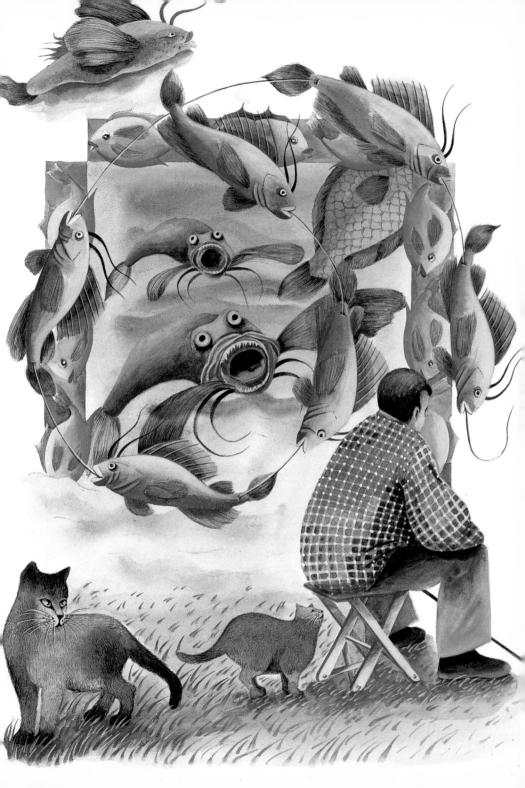

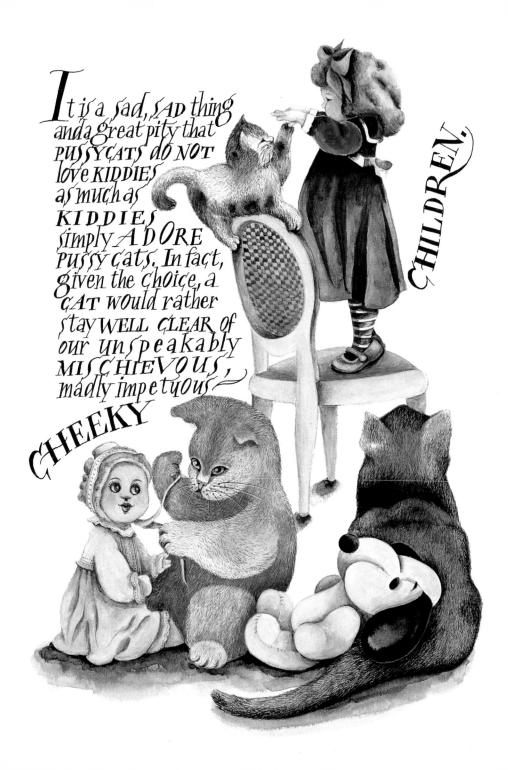

Notably, tyrannigal little TODDLERS with their ANGELIC, in Sennous faces. Behind this pristine, CHER UBICS persona, an innate fascination of DIABOLICAL DELIGHTS thrives potent and unbridled. ATROCITIES Such as bea/t by a SINGLE PAW UNGAINLY SUSPENSION are not NW 30 alberry uncommon Playful Pastimes which invariably incite: the GIGGLES. Due credit is given to Carloving parents who aspire to explain the susceptibility and SENSITIVITY of the CAT. That, TRACTABLE AS he may seem, pussy will attack vicioùsix if provoked beyond REÁSONABLE ENDURANÇE. That a CAT is a mighty PROUD and POWERFUL and very Precious beast. And NOT a BIT like: LIYor Guddly brown BEA It is a GAT. And a GAT is NOT a TOY.

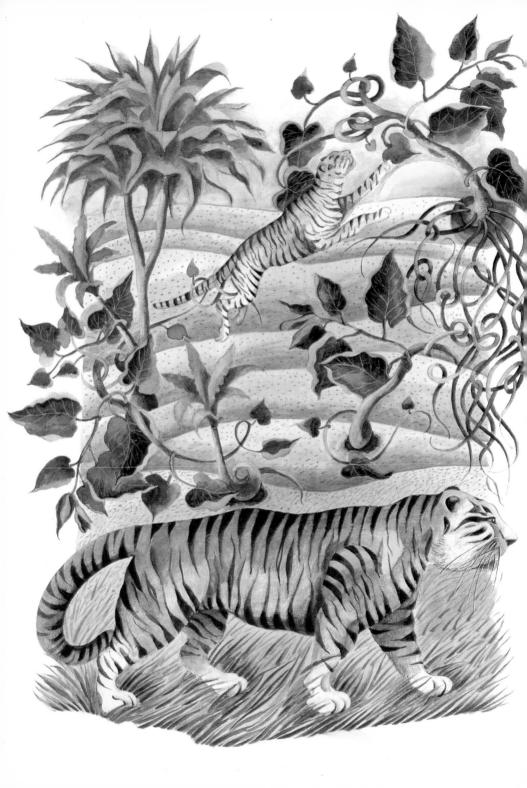

rom the Wilds to Wanton Alley. Is he bound for destitution or is he a regal giant in diguise? Beware, take heed of TOBIAS TYRANNICUS TOM as he strides hungrily, menacingly, proudly through the debri, dereliction, disposals and dirt. His instincts are primeval; his claw lethal; his domesticity purely fictional. TOM is the PRINCE of PREDATORS. His pure conceals an ancient, terrestrial growl deep within his feline entrails. Lawless and Lithe and Lascivious, he has the TIGEREMBODIED IN HIS SOUL.

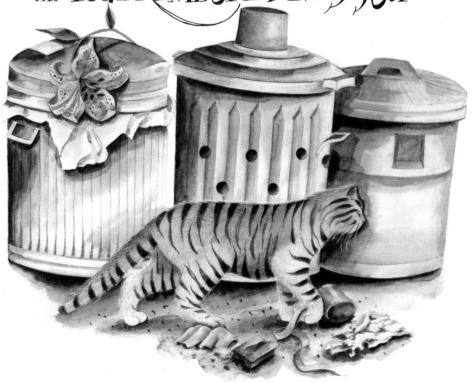

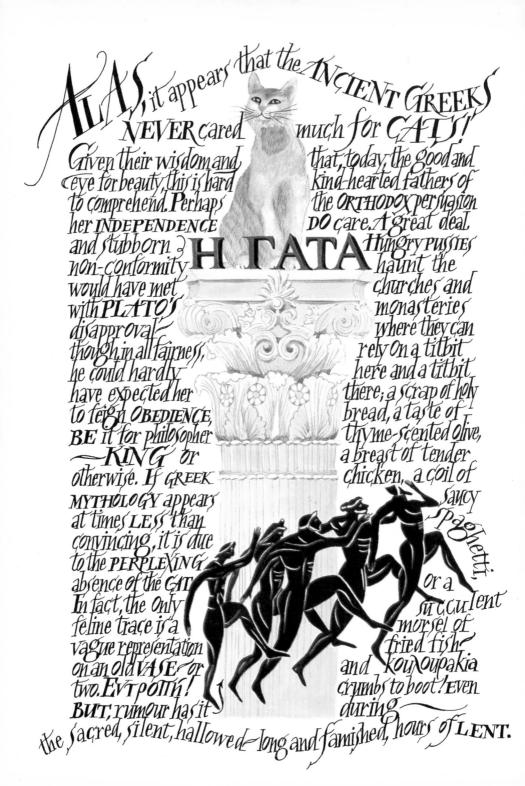

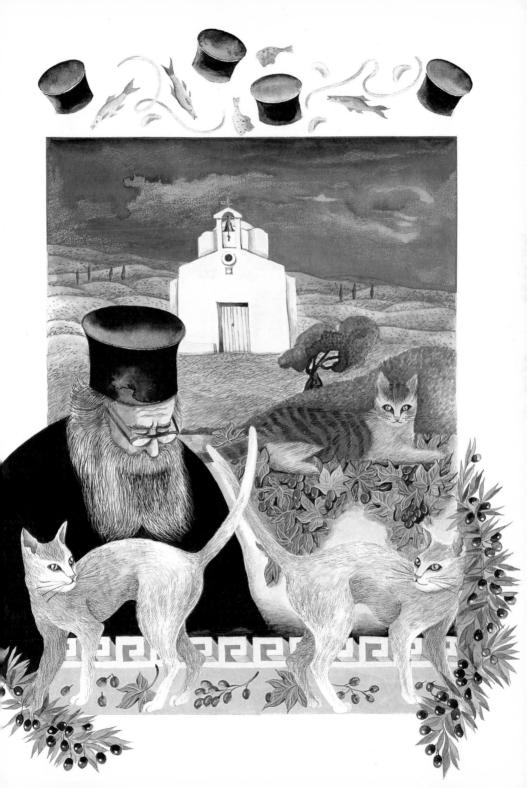

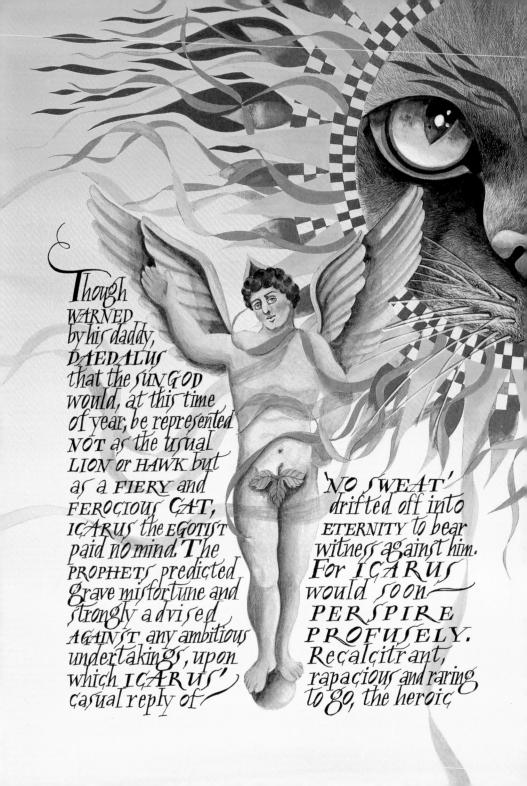

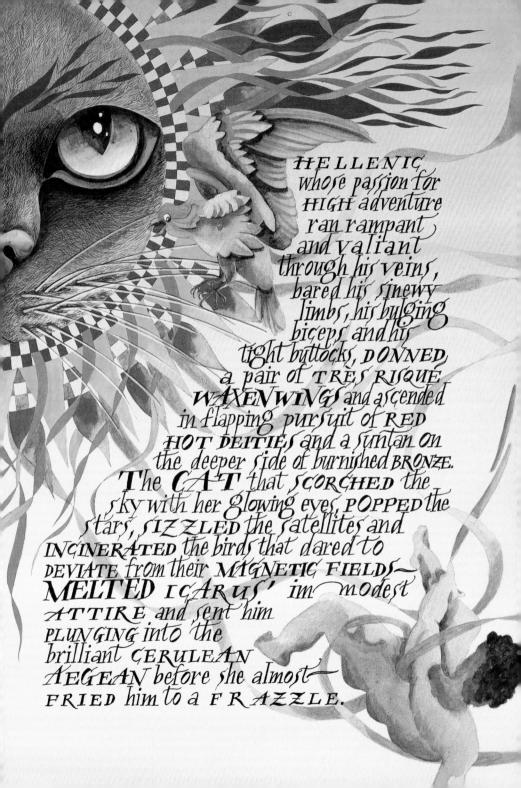

Vith bloodshed inscribed in his beguiling blue eyes and the speed of lightning in his limbs, he scrambled up the trees, snatched the nests and BUMPED-OFF every baby BIRD born in the spring of 1984. It was DEATH ROW for all weak and vunerable and detenceless winger critters within a 2 mile radius of what he arbitrarily claimed as His territory: a domain carpeted with feathers. His coat was as WHITE as VIRGIN snow; his disposition as FOUL as DRIVEN strust. He would gataput himself onto birds in mid-This is would cataput runged onto bling in into the flight, shake them senseless, transport them into the house and dump their peeping, panting, mangled carcasses moribund at my feet, while he waited impatiently for approval and due rewards. No amount of castigation could temper the blatant GLASNOST of his gruesome taste for tyranny and torture. No punitive procedures reformed his FELONIOUS Ways. Consolation came in the knowledge that extermination of the BIRD POPULATION WAS every healthy CATS idea of FUN and RECREATION. But, OSCAR was of mental stability: publous; of chromosomecount: suspect. It wasn't until ex-militiaman cum forest ranger alias breeder of dulcettoned songbirds stood at my gate with his WINCHE/TER 44 calibre pointing at SCAR who emanated INNOCENCE

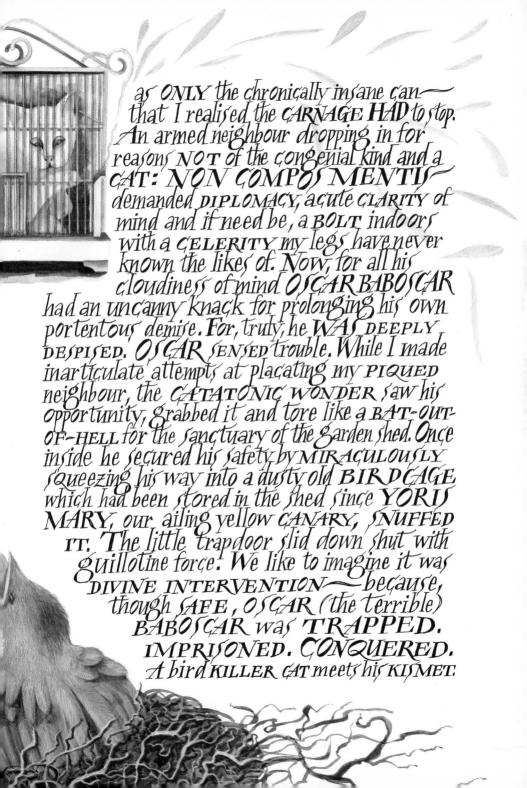

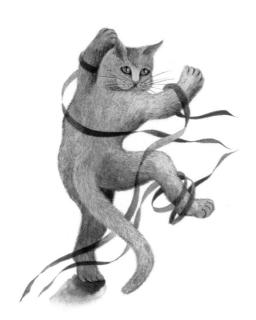

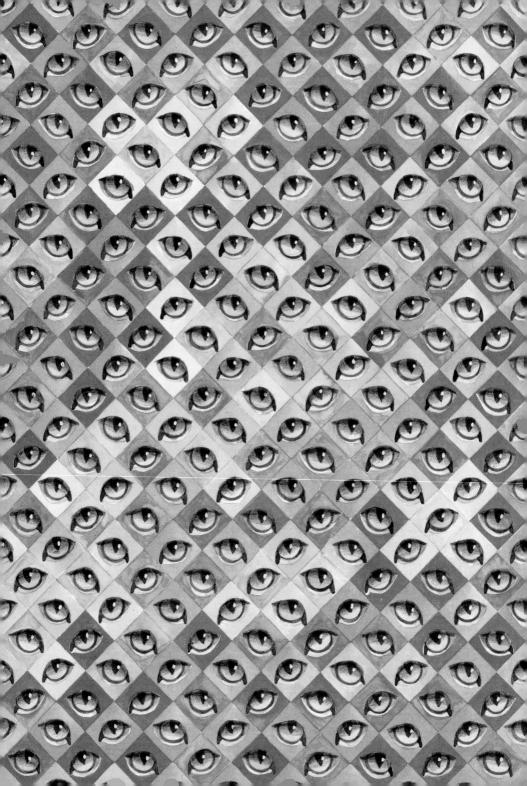